EBONY ESSENCE THROUGH TIME

A COLORING BOOK FOR GROWN UPS CELEBRATING AFRICAN AMERICAN HISTORY

By Dr. LaShawnda Lindsay-Dennis,
The Crafty Ph.D.

Ananse Design Essentials

Ebony Essence Through Time: A Coloring Book for Grown Ups Celebrating African American History
Copyright © 2018 LaShawnda Lindsay-Dennis, Ph.D.

All rights reserved. This book or any portion thereof may not be reproduced or used in any manner whatsoever without the express written permission of the publisher except for the use of brief quotations in a book review.

ISBN: 9781794011670

Cover and book design by Megan Cassidy
All text and illustrations:
Copyright © 2019 LaShawnda Lindsay-Dennis, Ph.D.

First Printing

Published by Ananse Design Essentials

Learn More: AnanseDesignEssentials.com

To my parents, Joyce Lindsay and Jesse L. Pender.

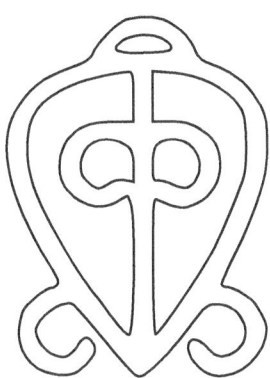

Thank you for your unconditional love and support.

"In order to understand our present and ensure our future, we must know our past."

Sankofa is a concept derived from the Akan people of West Africa. Sankofa is expressed in the Akan language as "se wo were fi na wosan kofa a yenki." The literal translation in English "it is not taboo to go back and fetch what you forgot." The visual and symbolic representation of Sankofa is expressed as a mythic bird that flies forward with its head turned backward carrying an egg (representing the future) in its mouth.

This current work, *Ebony Essence Through Time*, draws upon Sankofa and allows for you to learn from public and private heroes and heroines who have shaped and continue to shape African American life and culture. Each image and the symbolic representation embedded in each image teach us that we must go back to our roots in order to move forward.

I encourage you to not only color the images but to learn more about each individual represented so that you gather the best of what our past has to teach us, so that we can achieve our full potential as we move forward and continue to build upon the legacies of our heroes and heroines.

— Dr. LaShawnda Lindsay-Dennis,
The Crafty Ph.D.

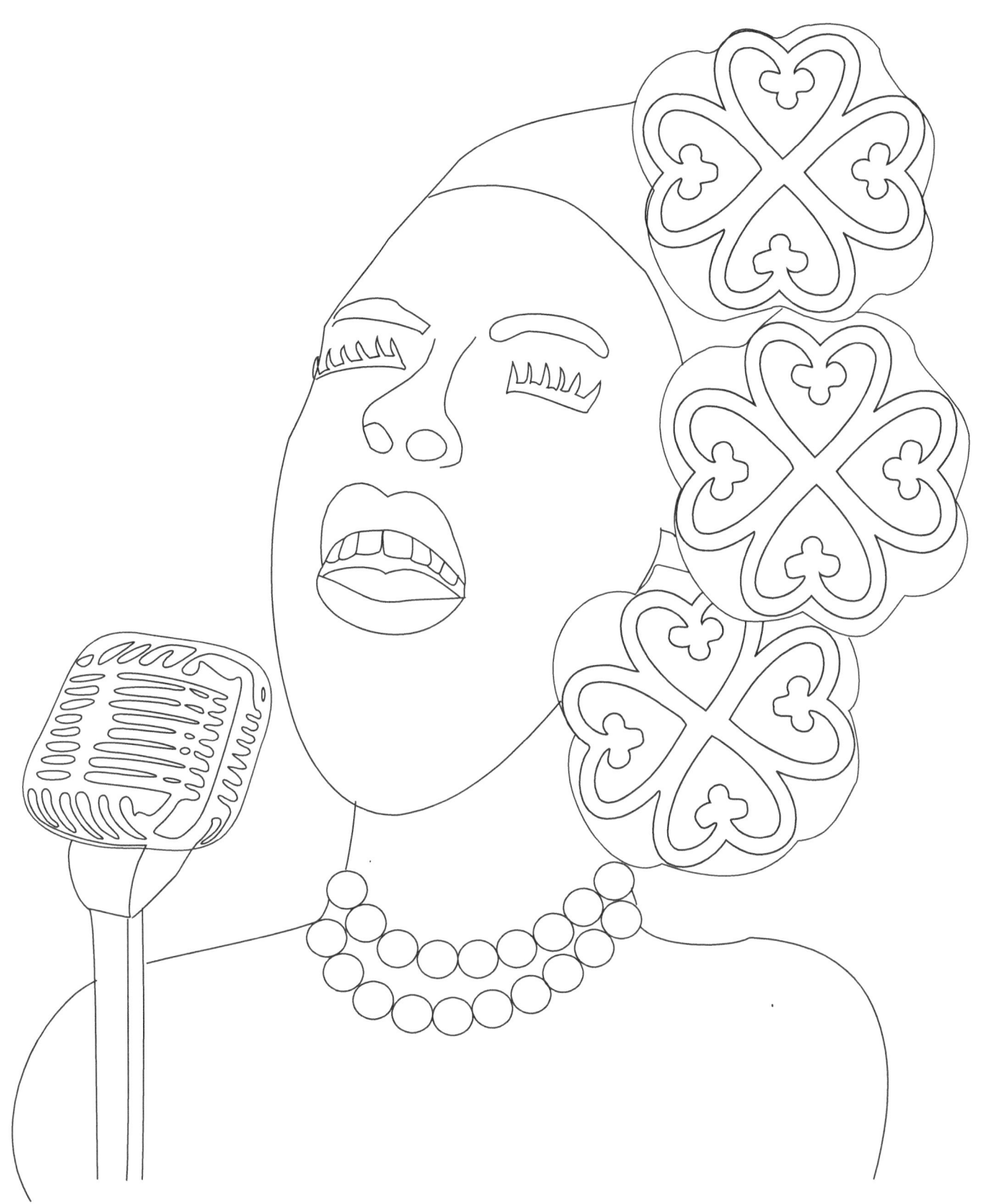

BILLIE HOLIDAY
SINGER

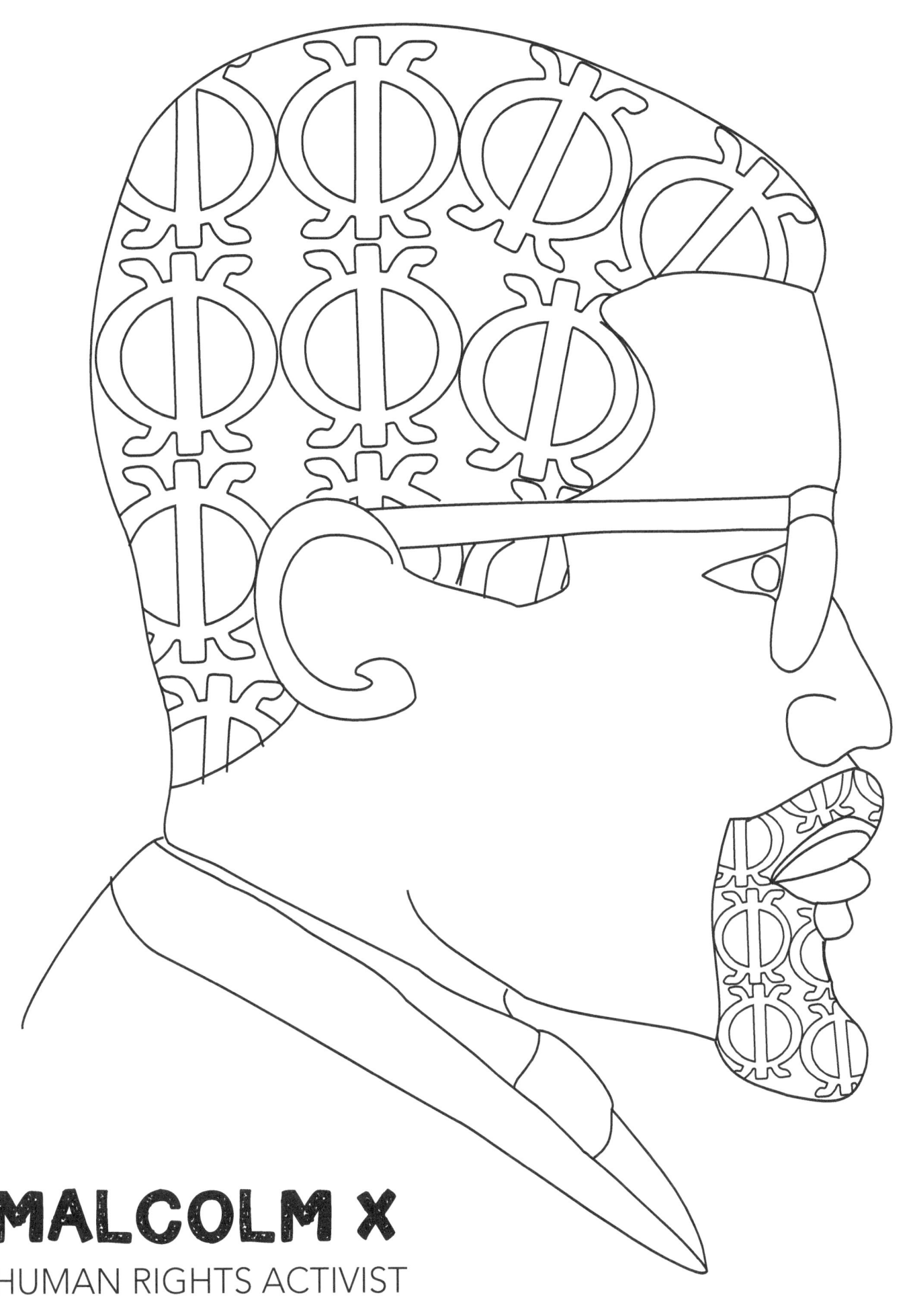

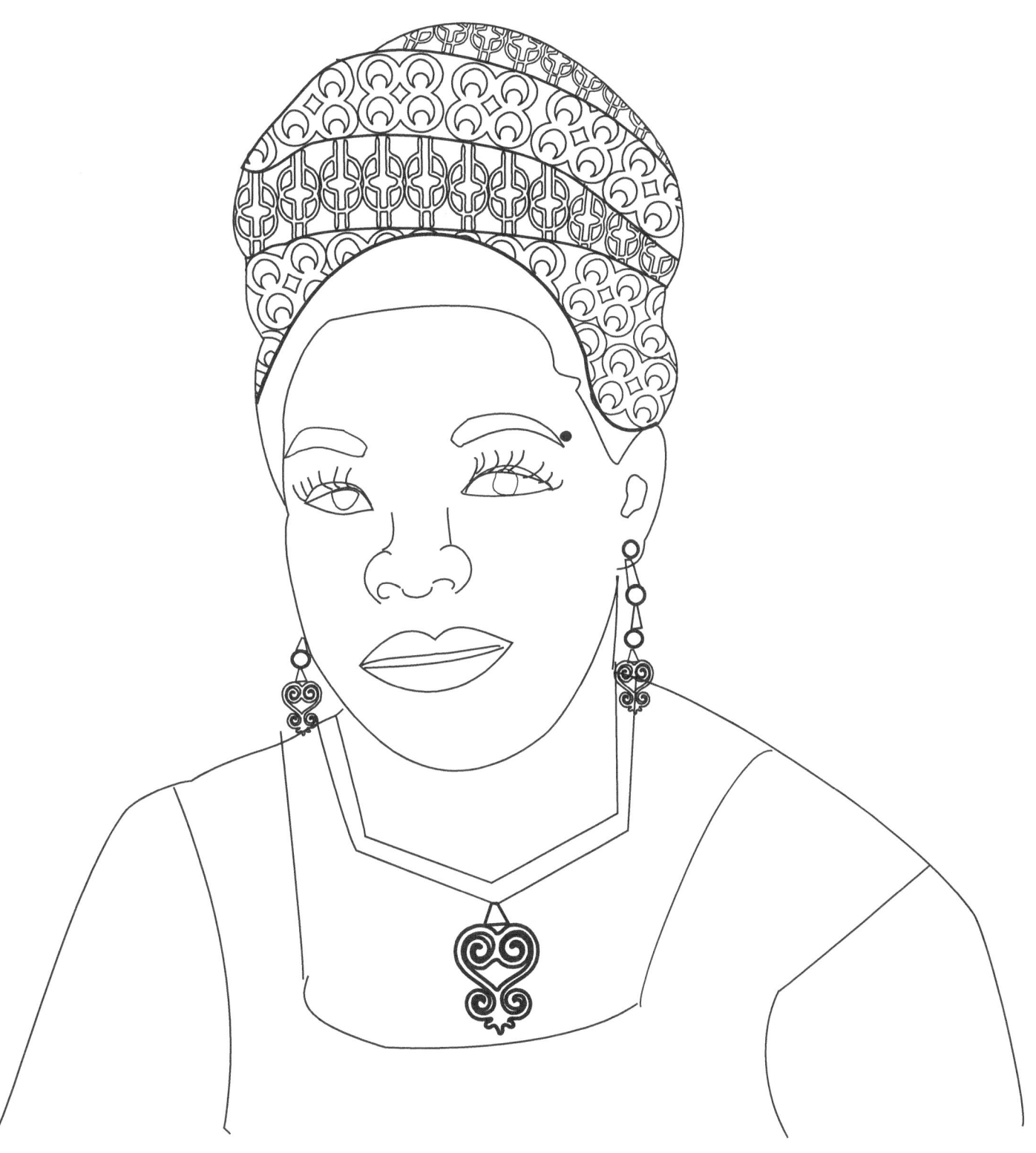

MAYA ANGELOU
POET

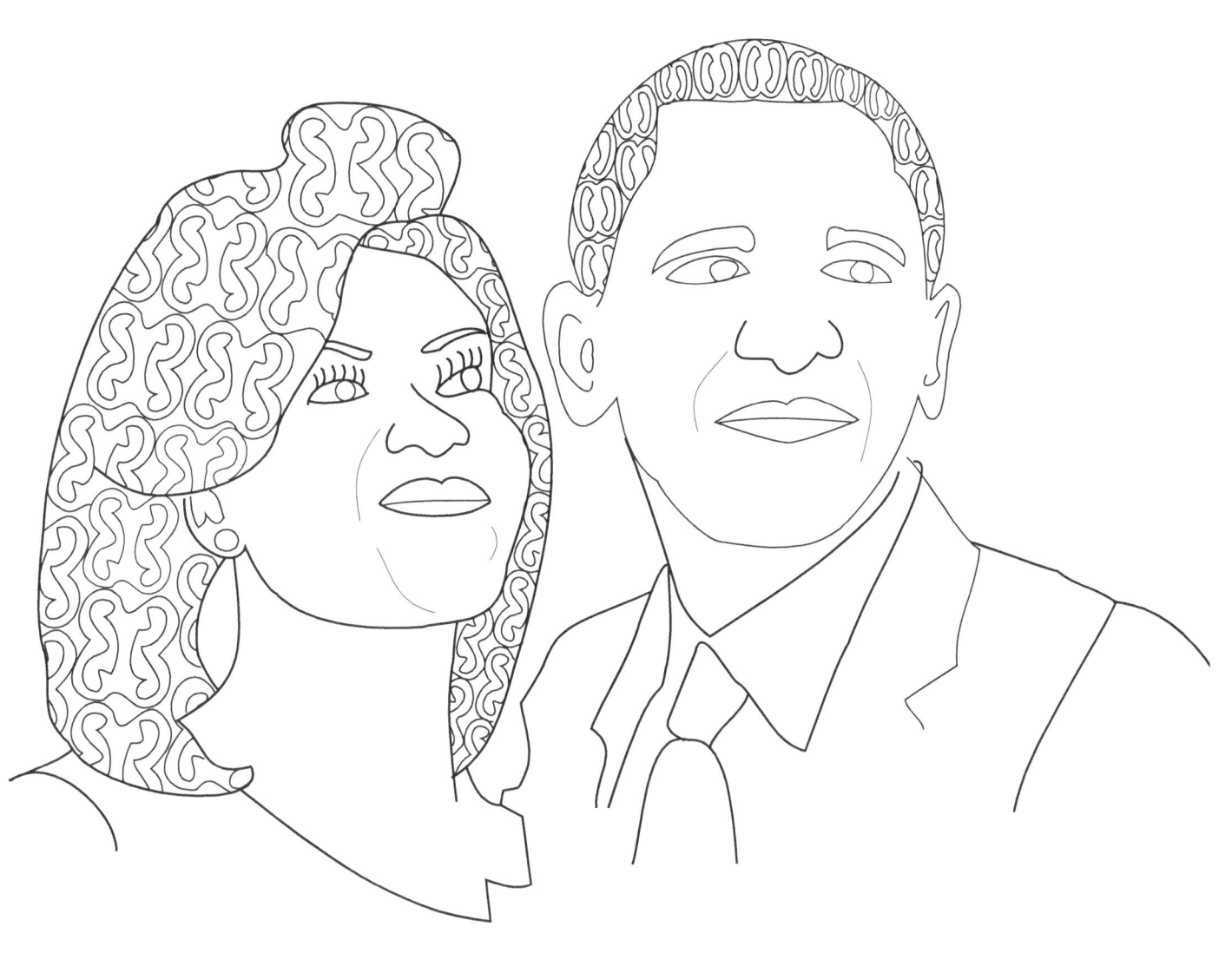

MICHELLE AND BARACK OBAMA

FIRST LADY AND PRESIDENT OF THE USA

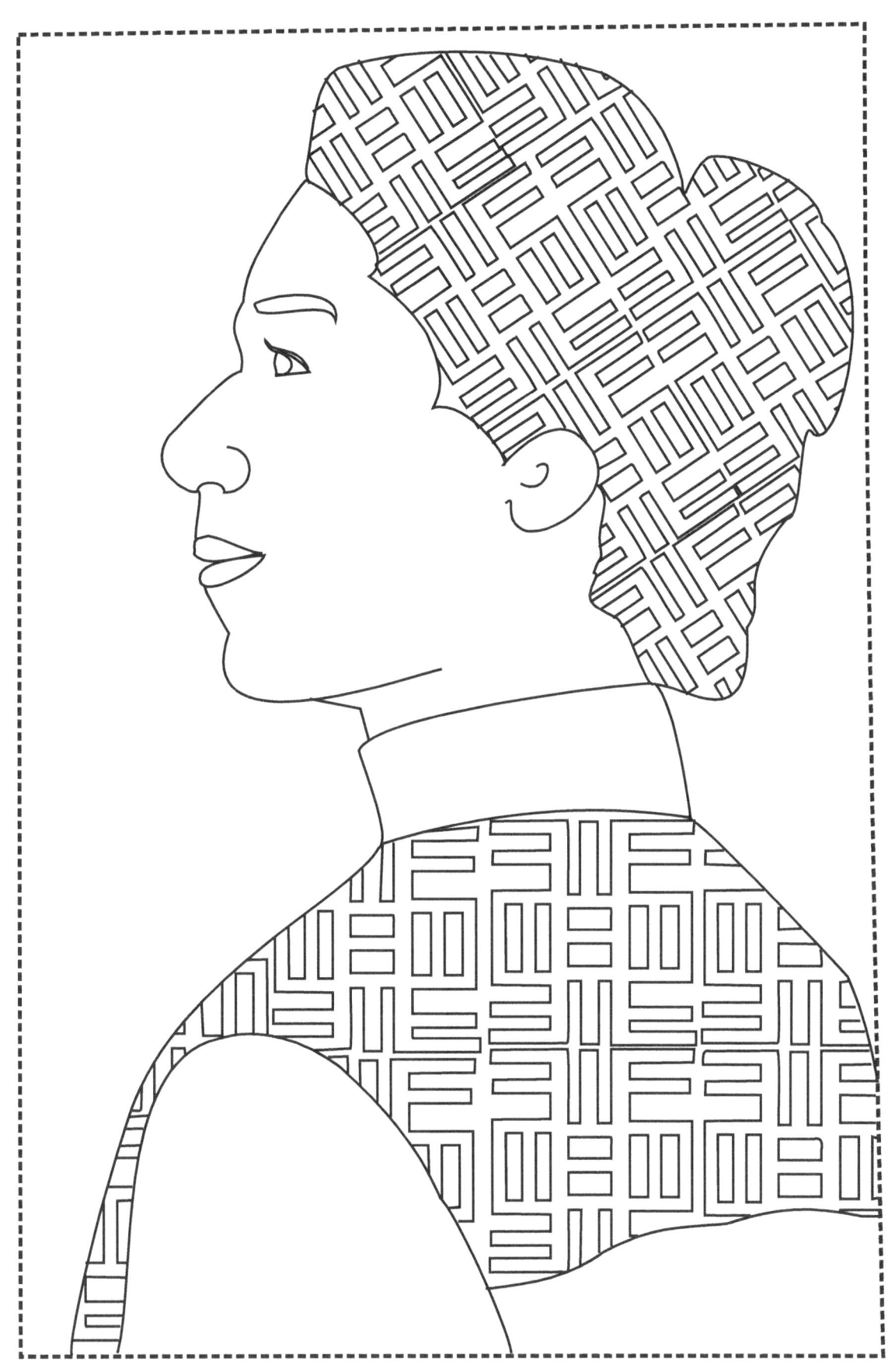

DR ANNA JULIA COOPER
EDUCATOR

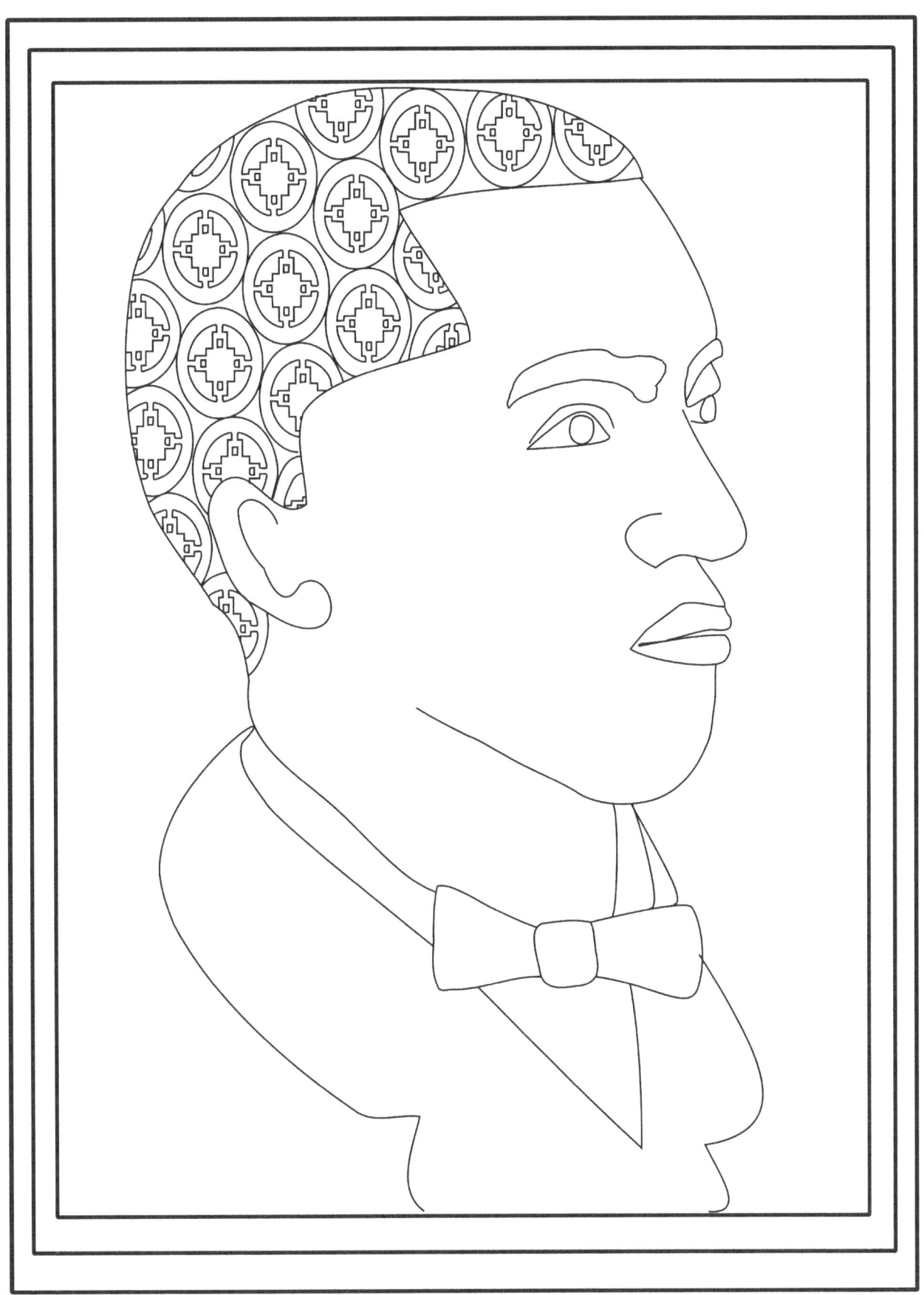

DR CARTER G WOODSON

HISTORIAN

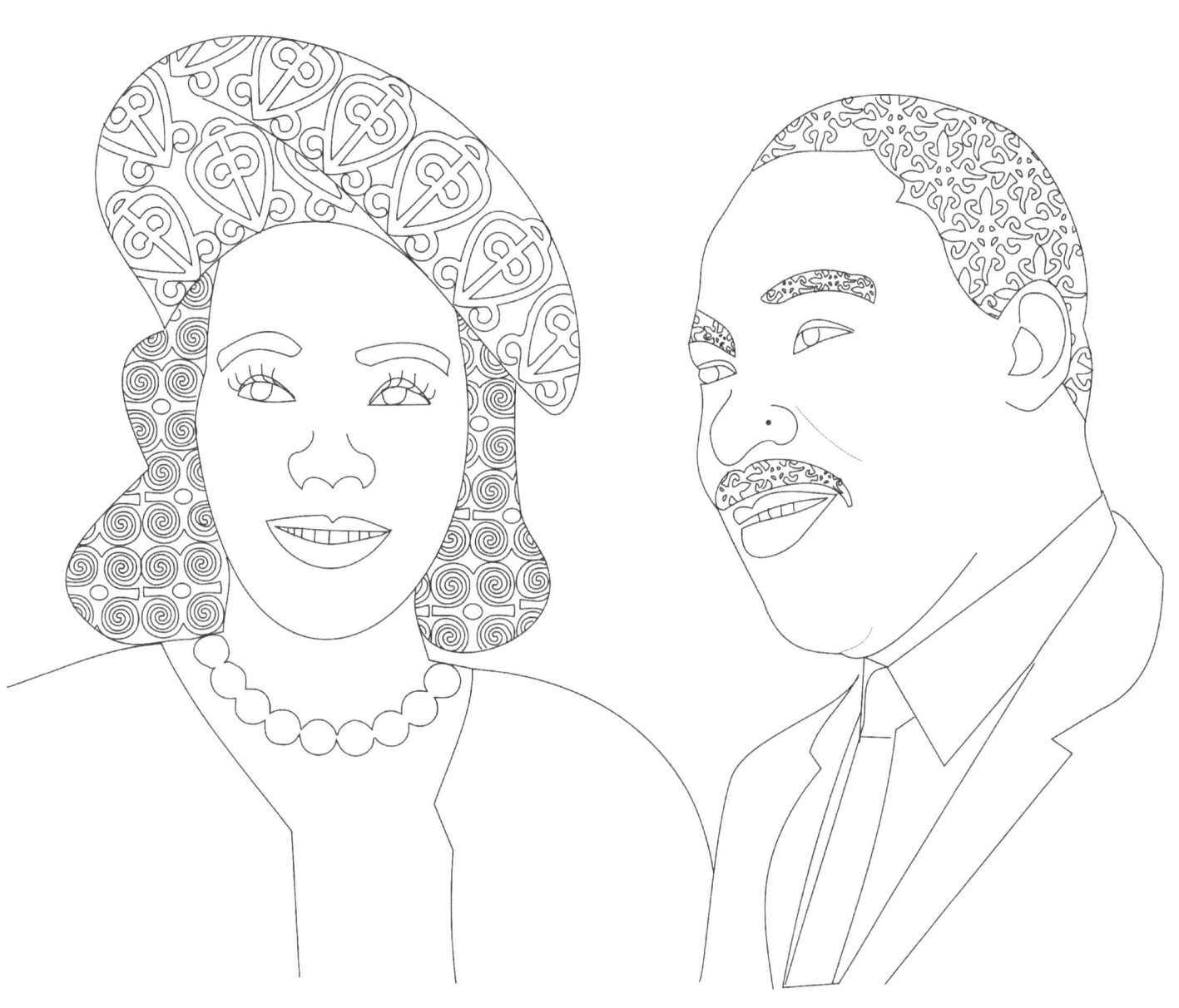

CORETTA SCOTT KING AND MARTIN LUTHER KING JR

CIVIL RIGHTS ACTIVISTS

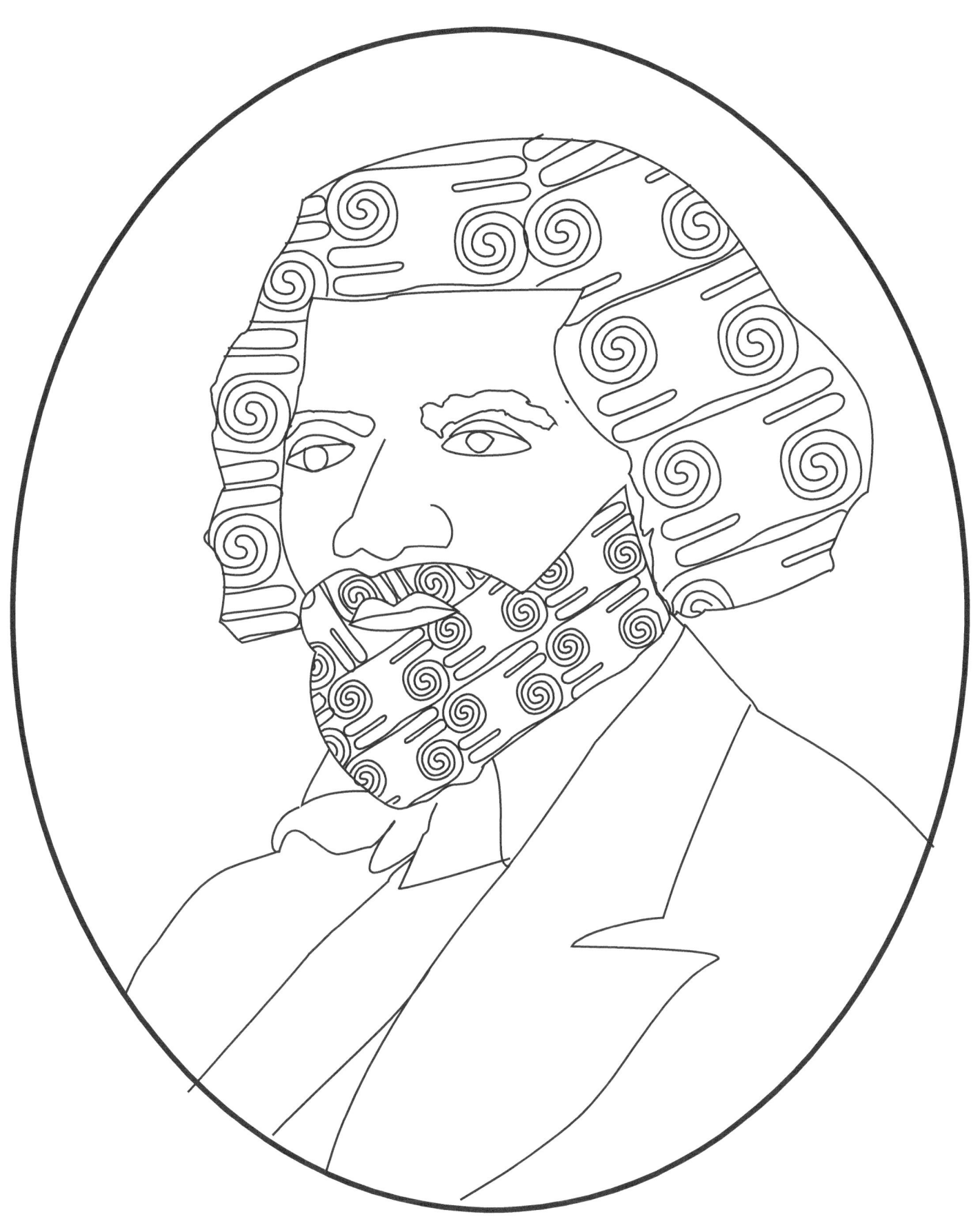

FREDERICK DOUGLASS
SOCIAL REFORMER

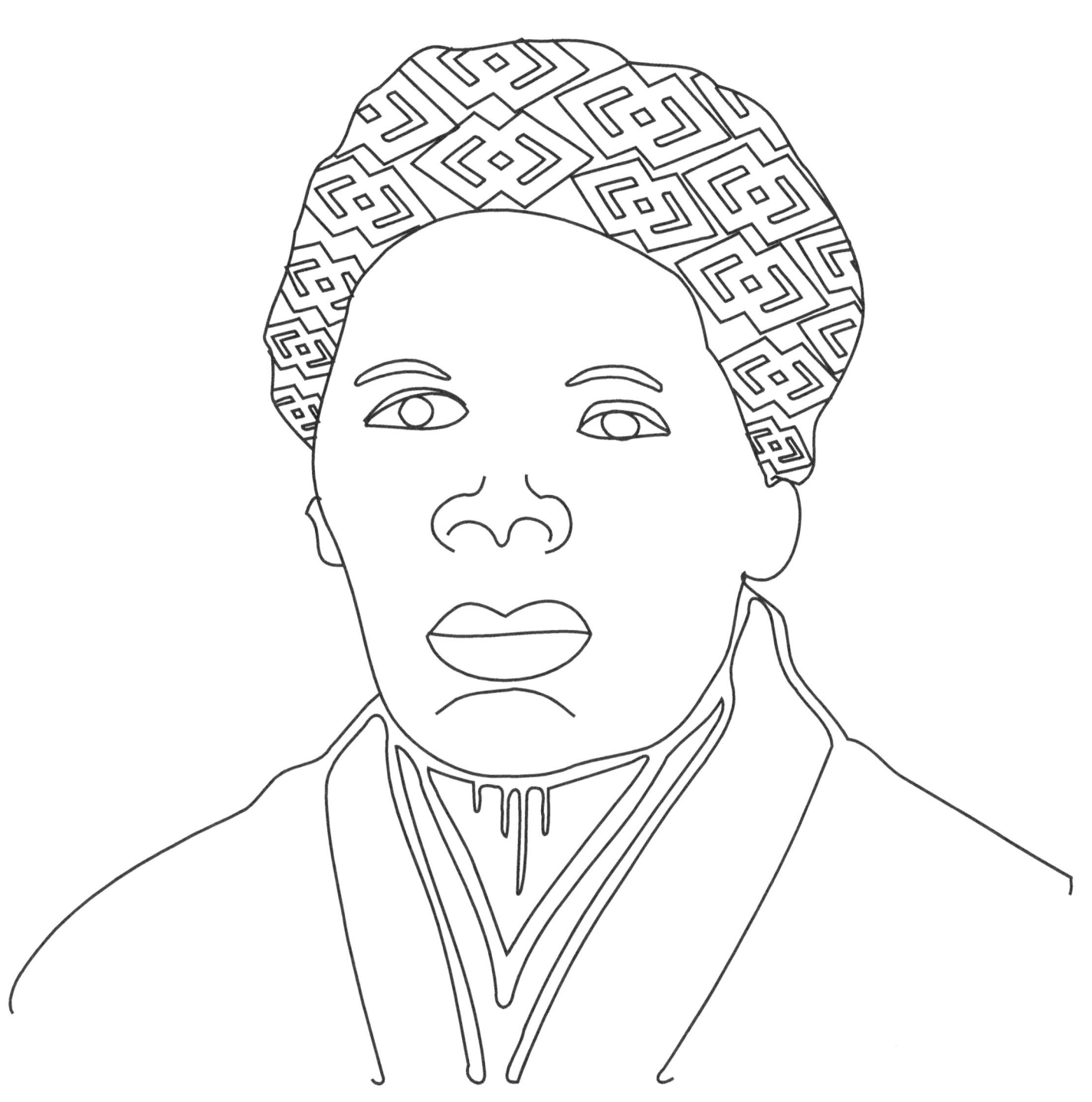

HARRIET TUBMAN
ANTISLAVERY ACTIVIST

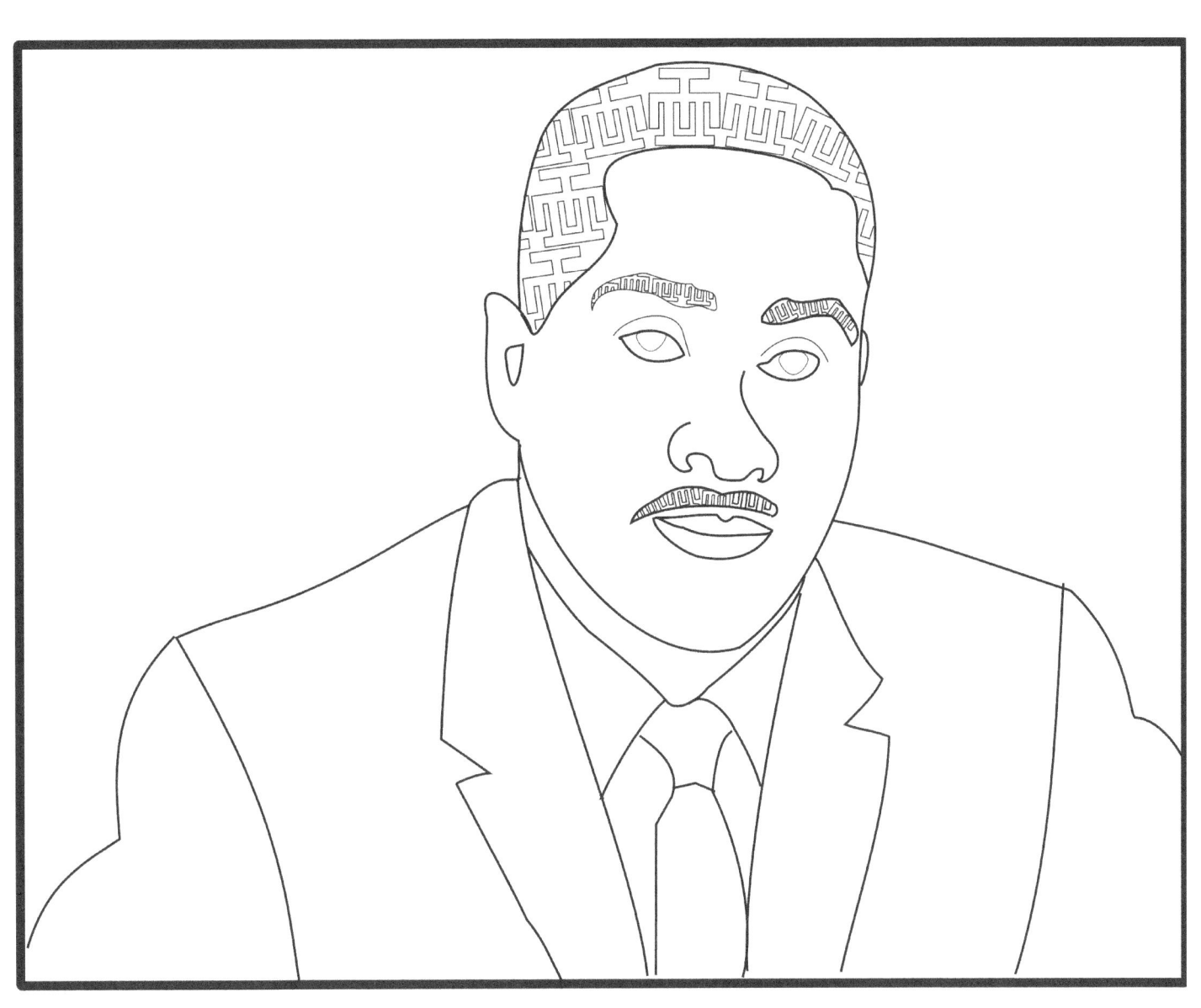

JOHN H JOHNSON

PUBLISHER AND BUSINESSMAN

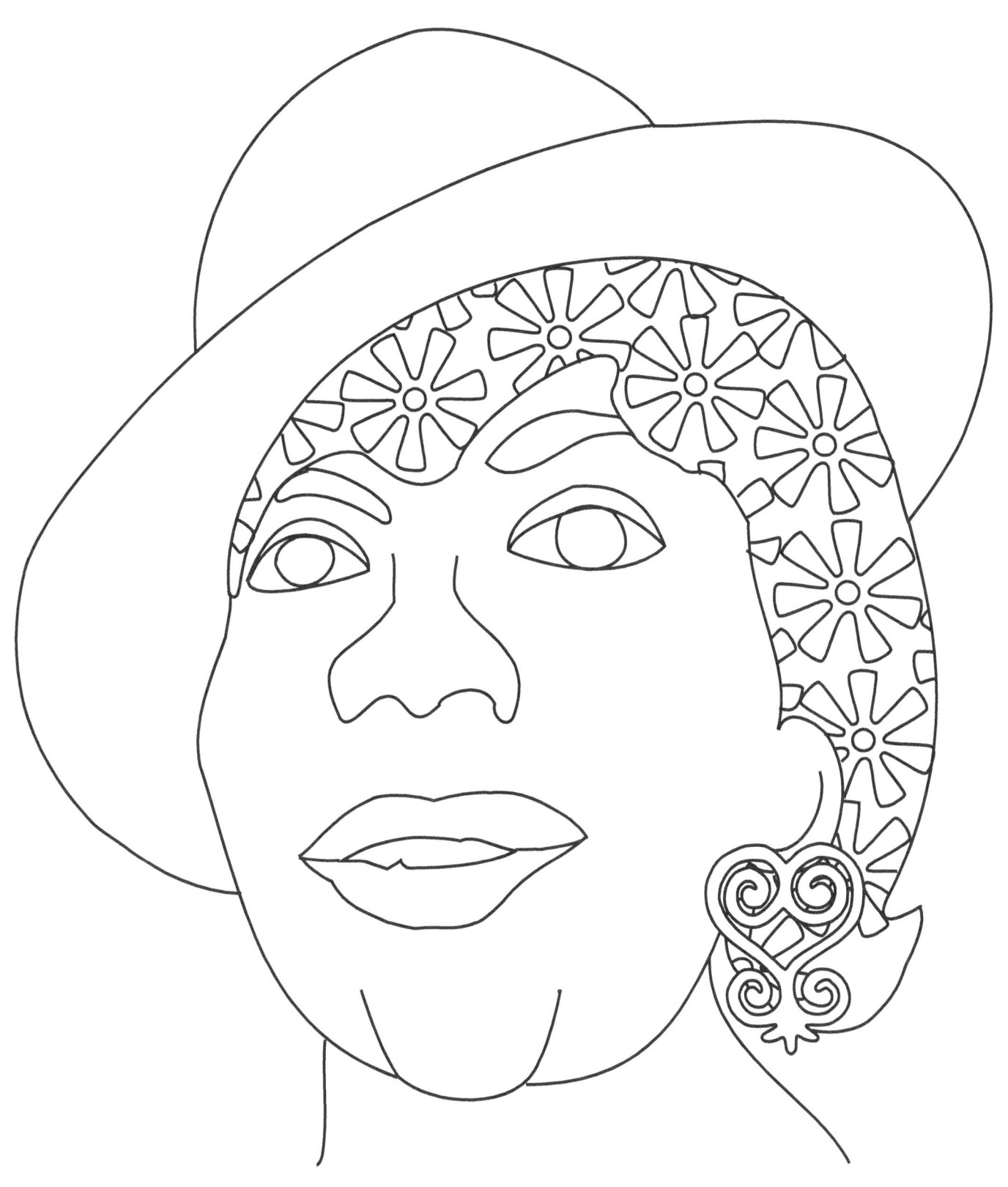

ZORA NEALE HURSTON
WRITER

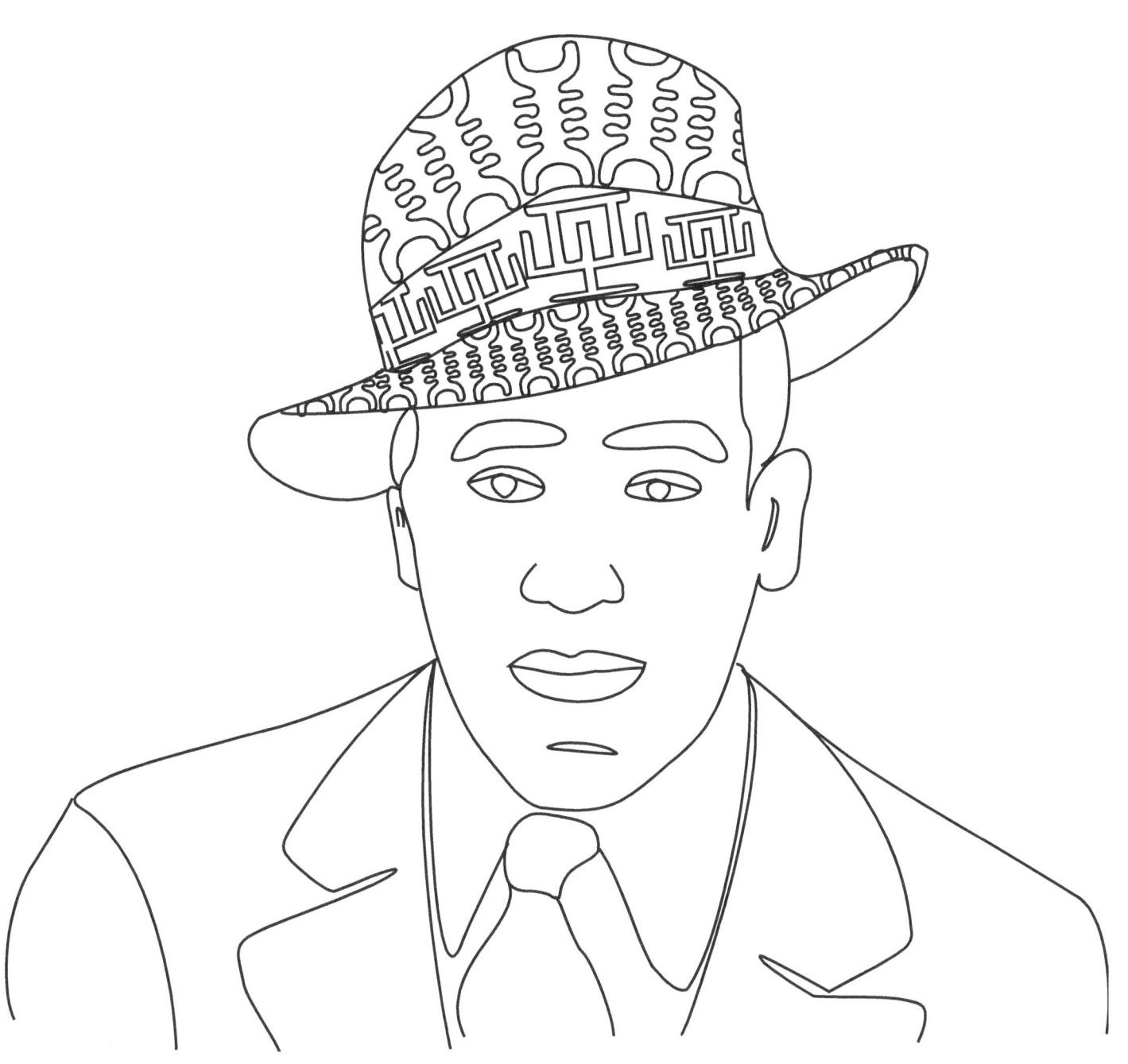

LANGSTON HUGHES
POET

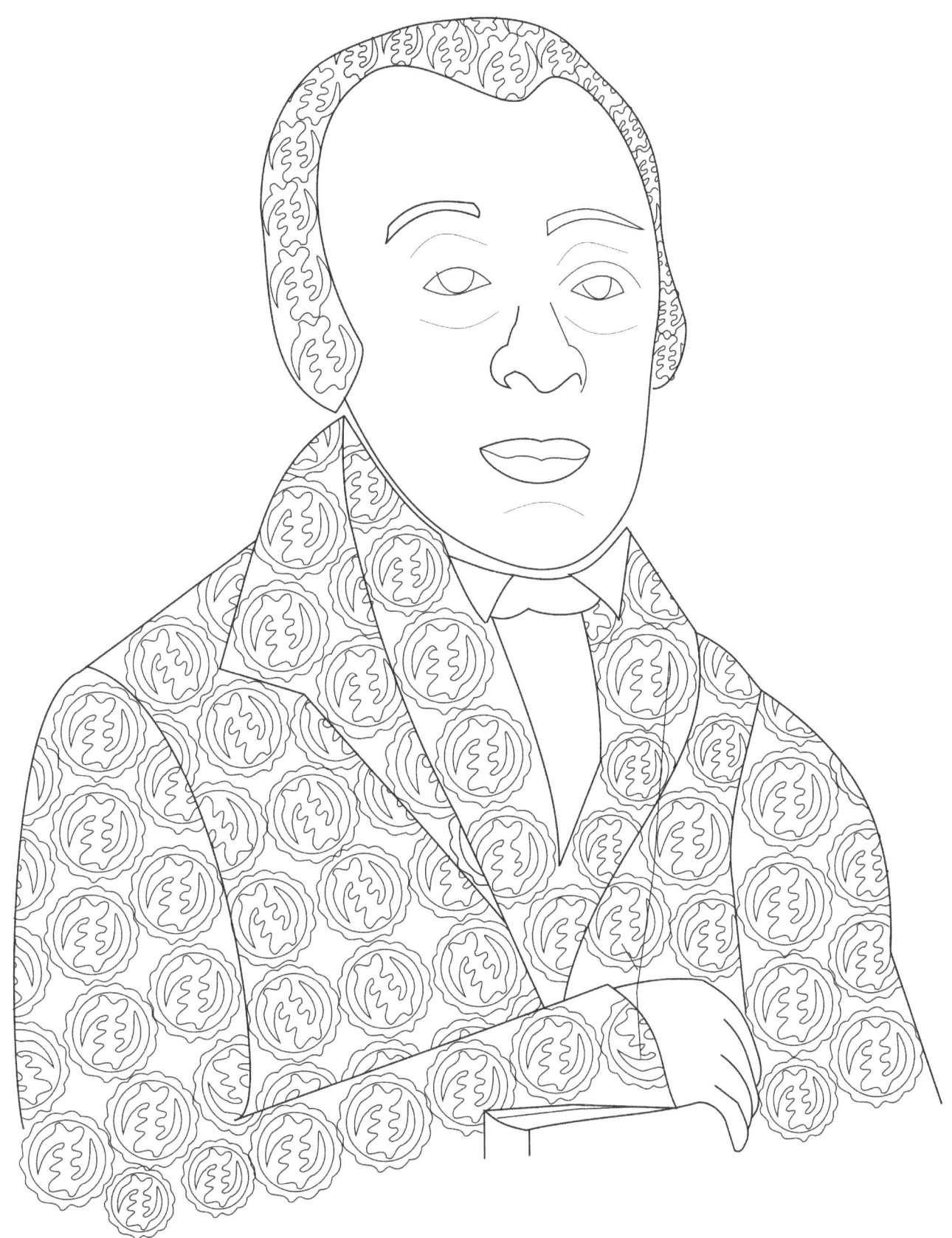

RICHARD ALLEN

FOUNDER OF THE AFRICAN METHODIST EPISCOPAL (AME) CHURCH

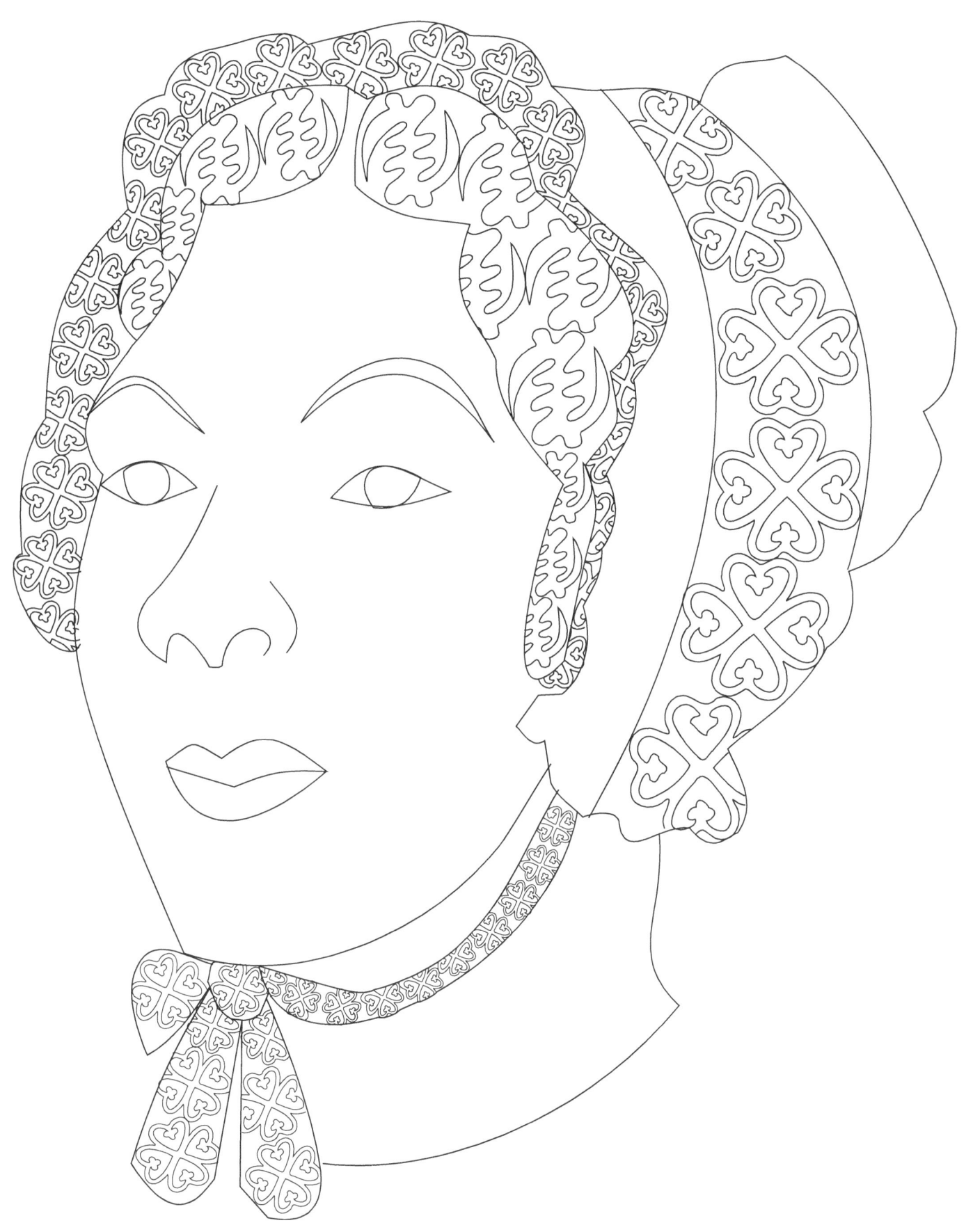

JARENA LEE

FIRST FEMALE PREACHER IN AME CHURCH

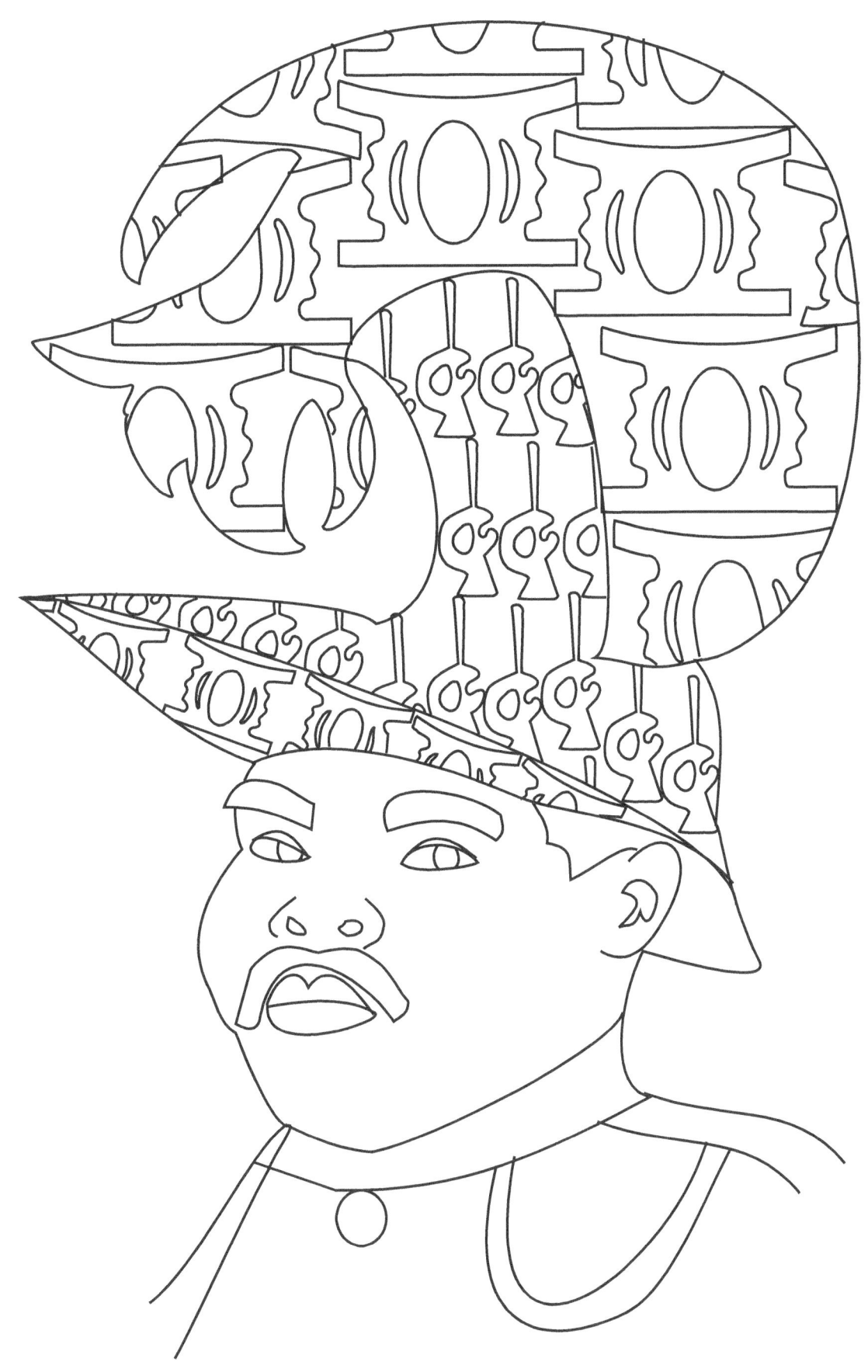

MARCUS GARVEY
POLITICAL LEADER

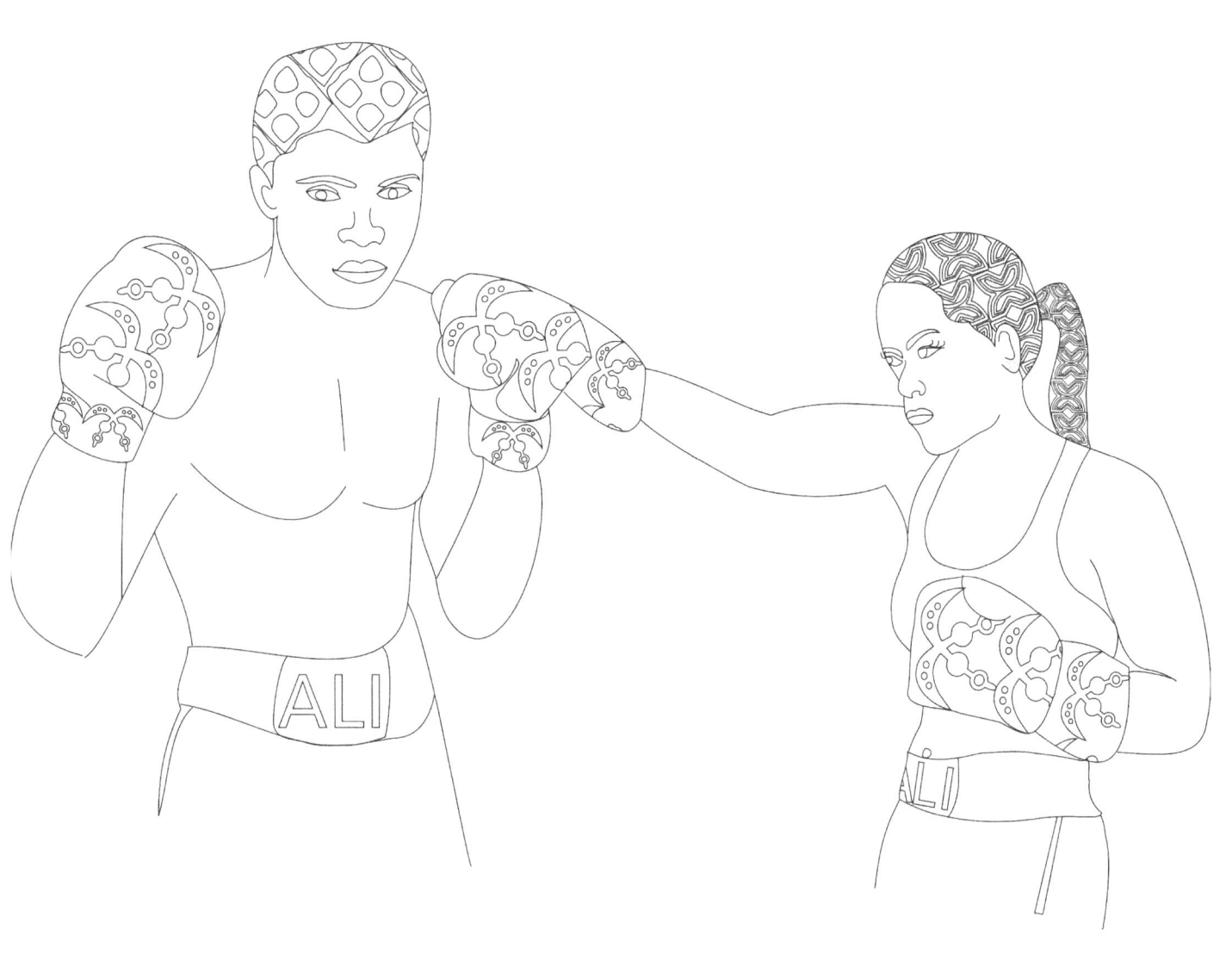

MUHAMMAD AND LAILA ALI
PROFESSIONAL BOXERS

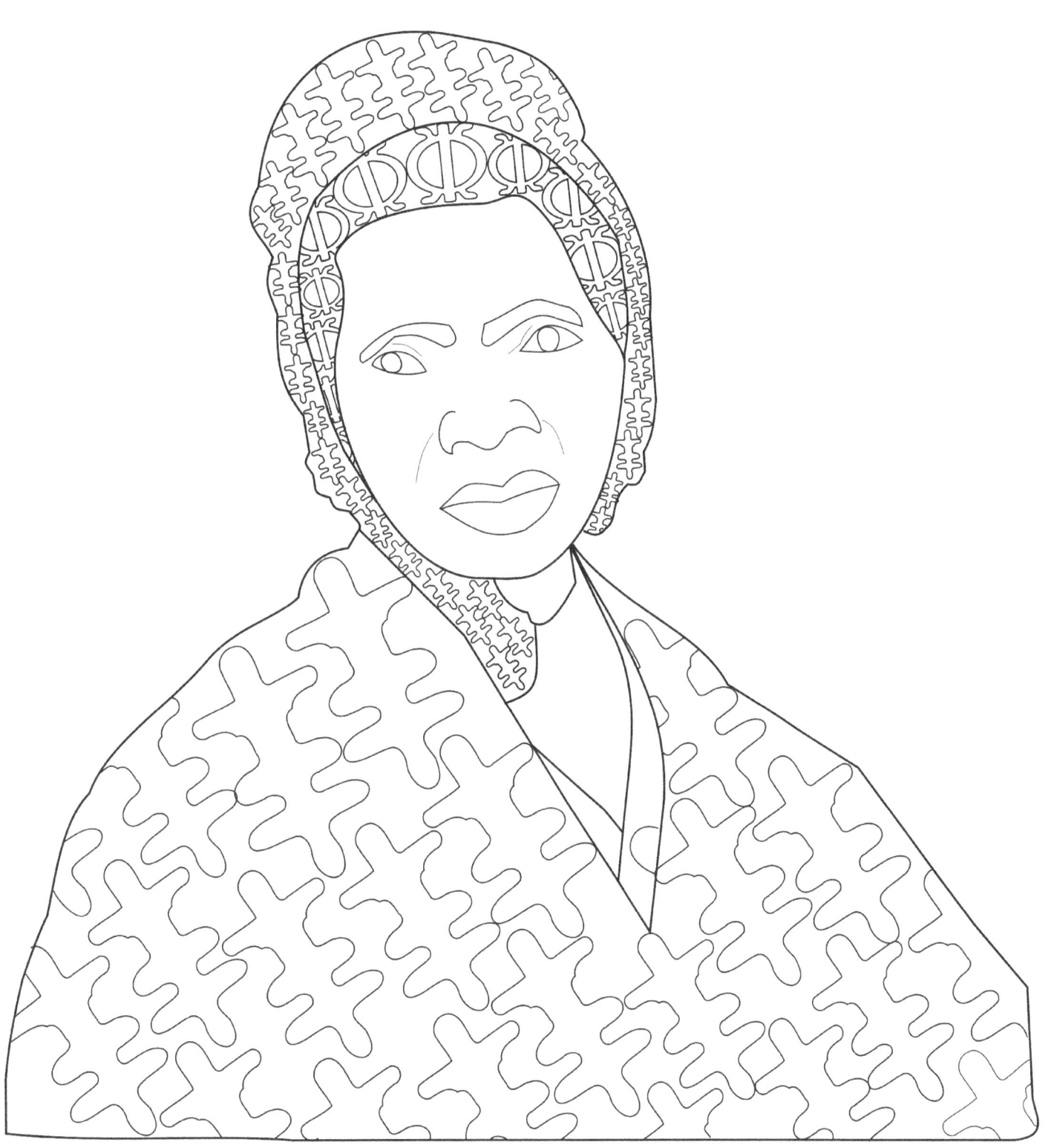

SOJOURNER TRUTH
WOMEN'S RIGHTS ACTIVIST

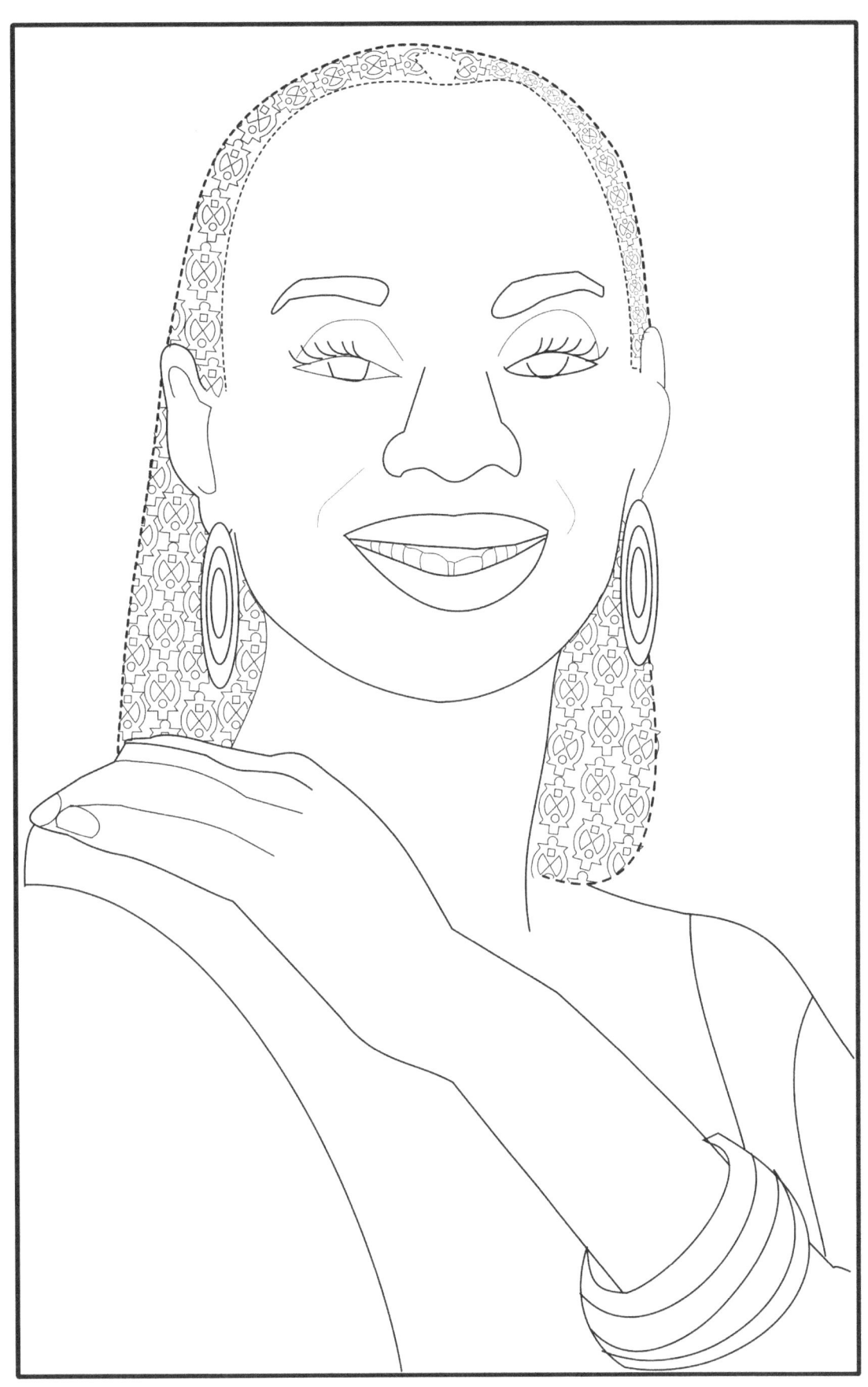

SUSAN L TAYLOR
EDITOR-IN-CHIEF EMERITA OF ESSENCE MAGAZINE

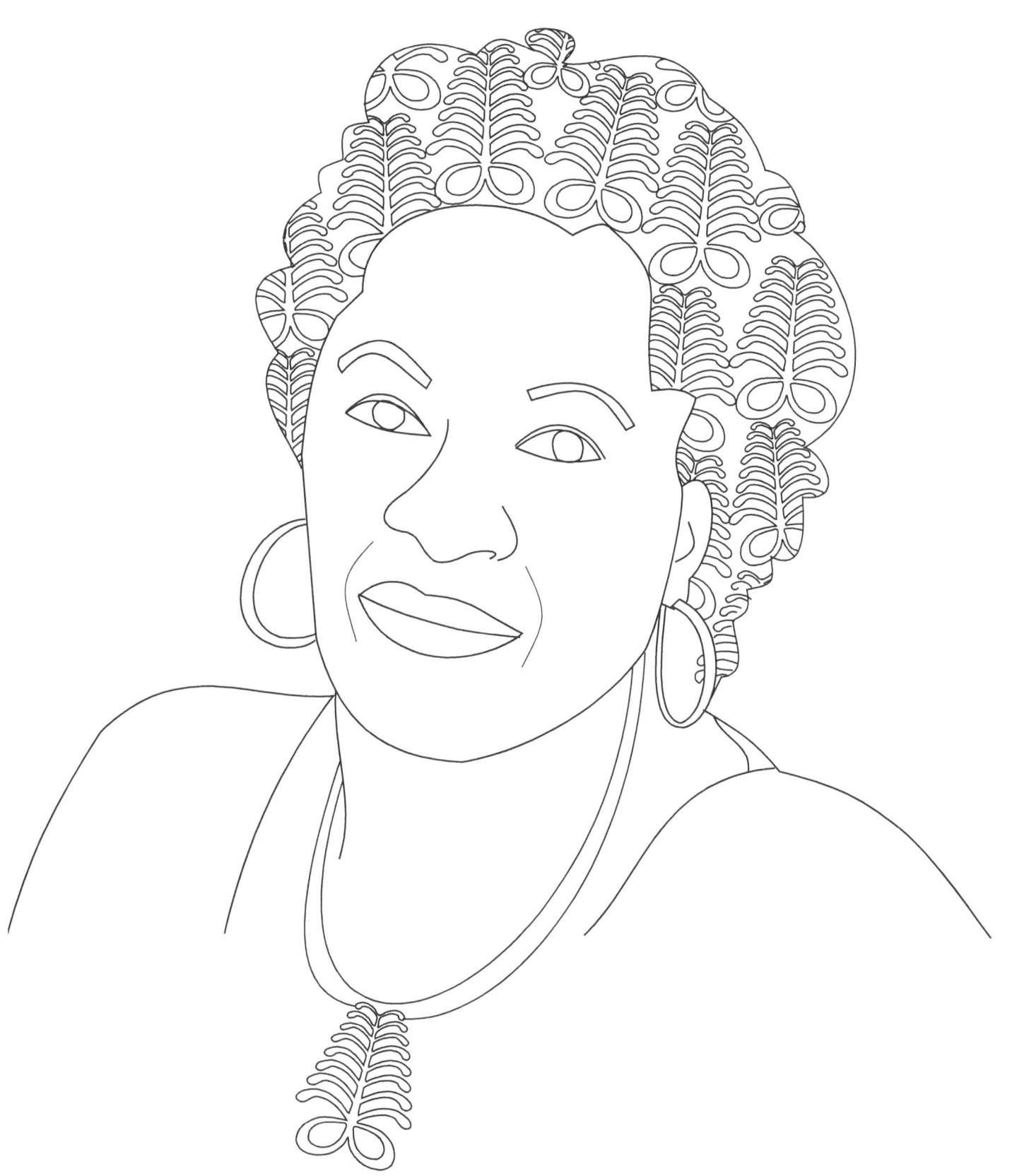

TONI MORRISON
WRITER

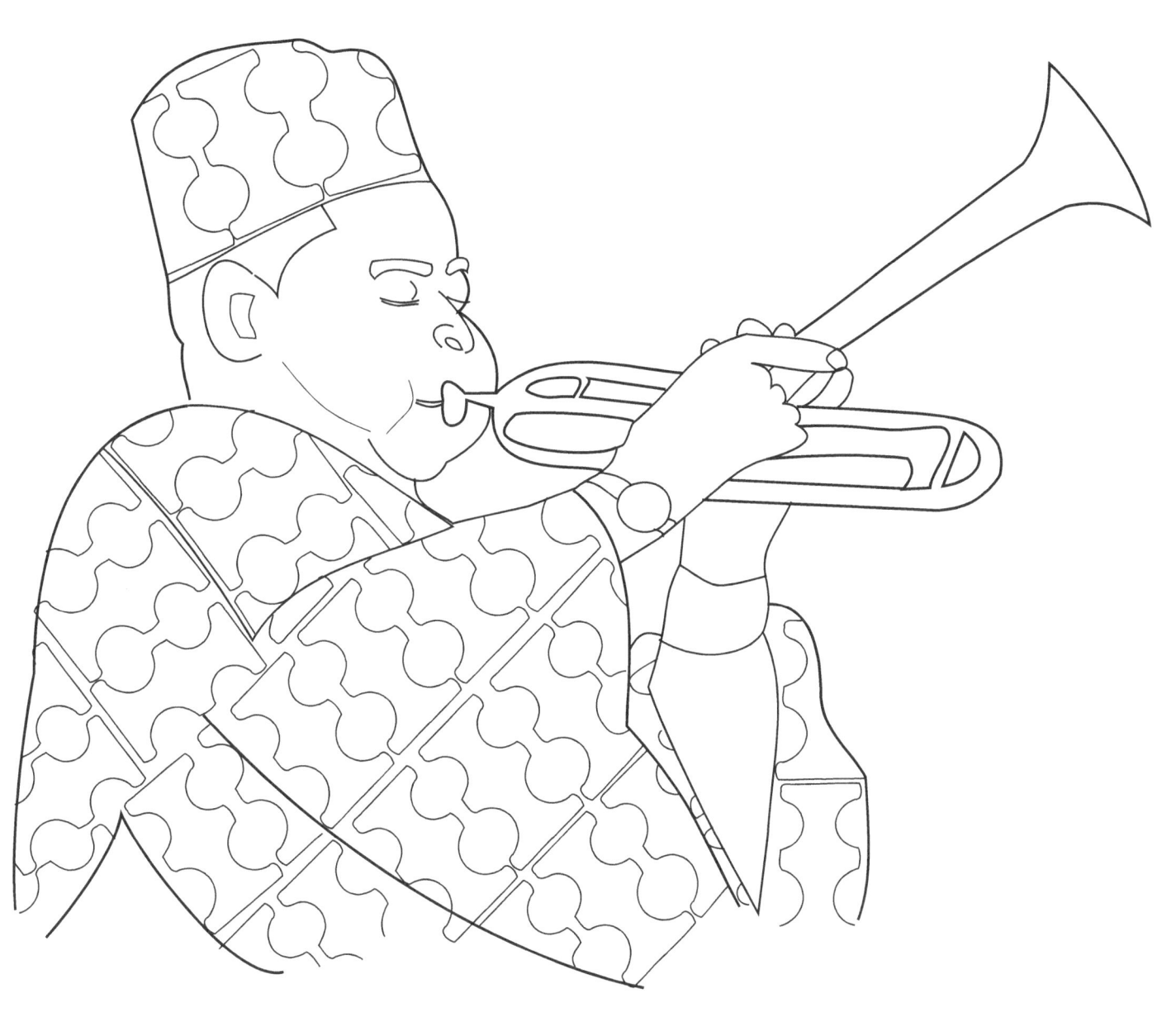

DIZZY GILLESPIE
JAZZ MUSICIAN

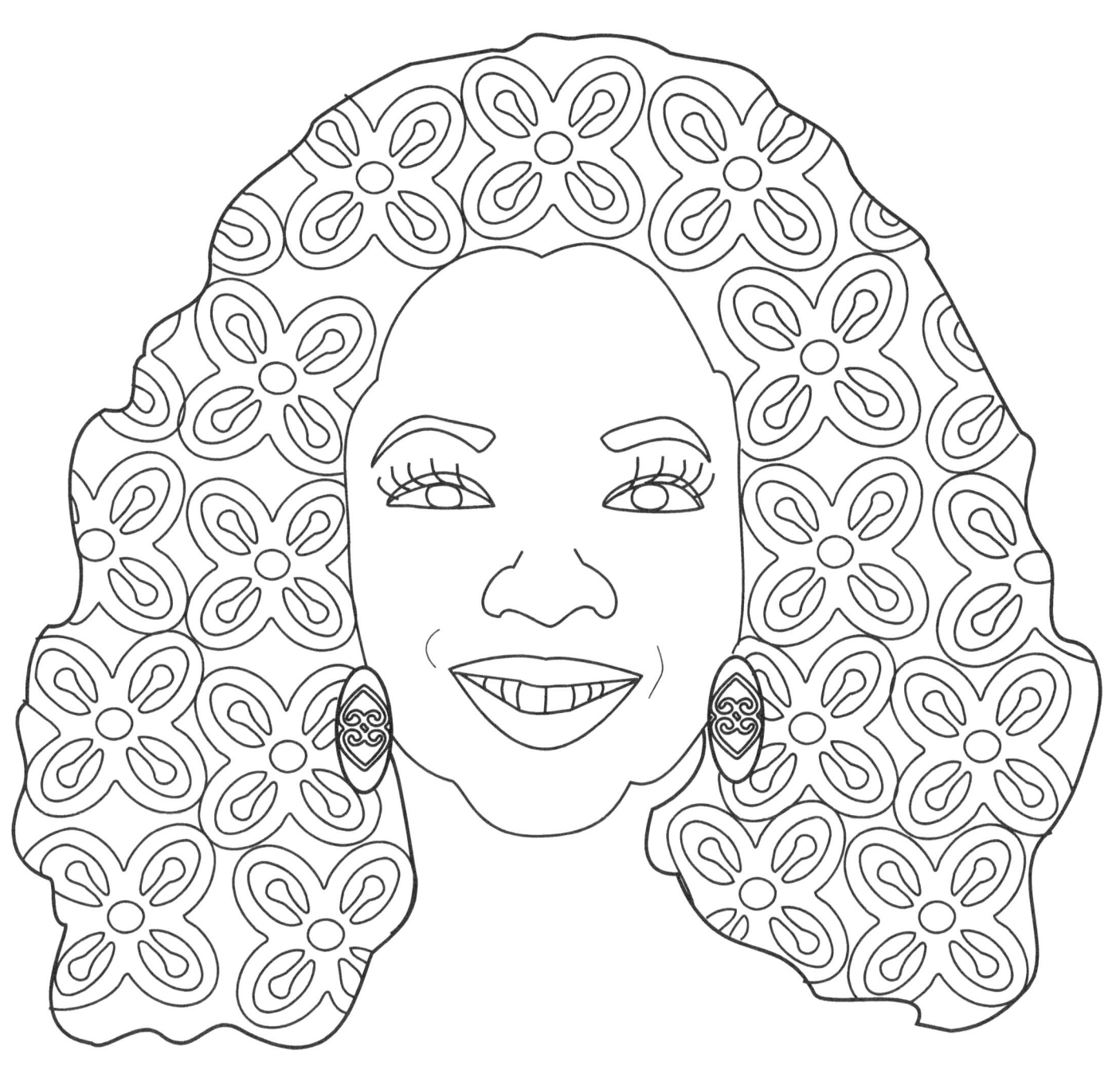

OPRAH WINFREY
MEDIA EXECUTIVE AND PHILANTHROPIST

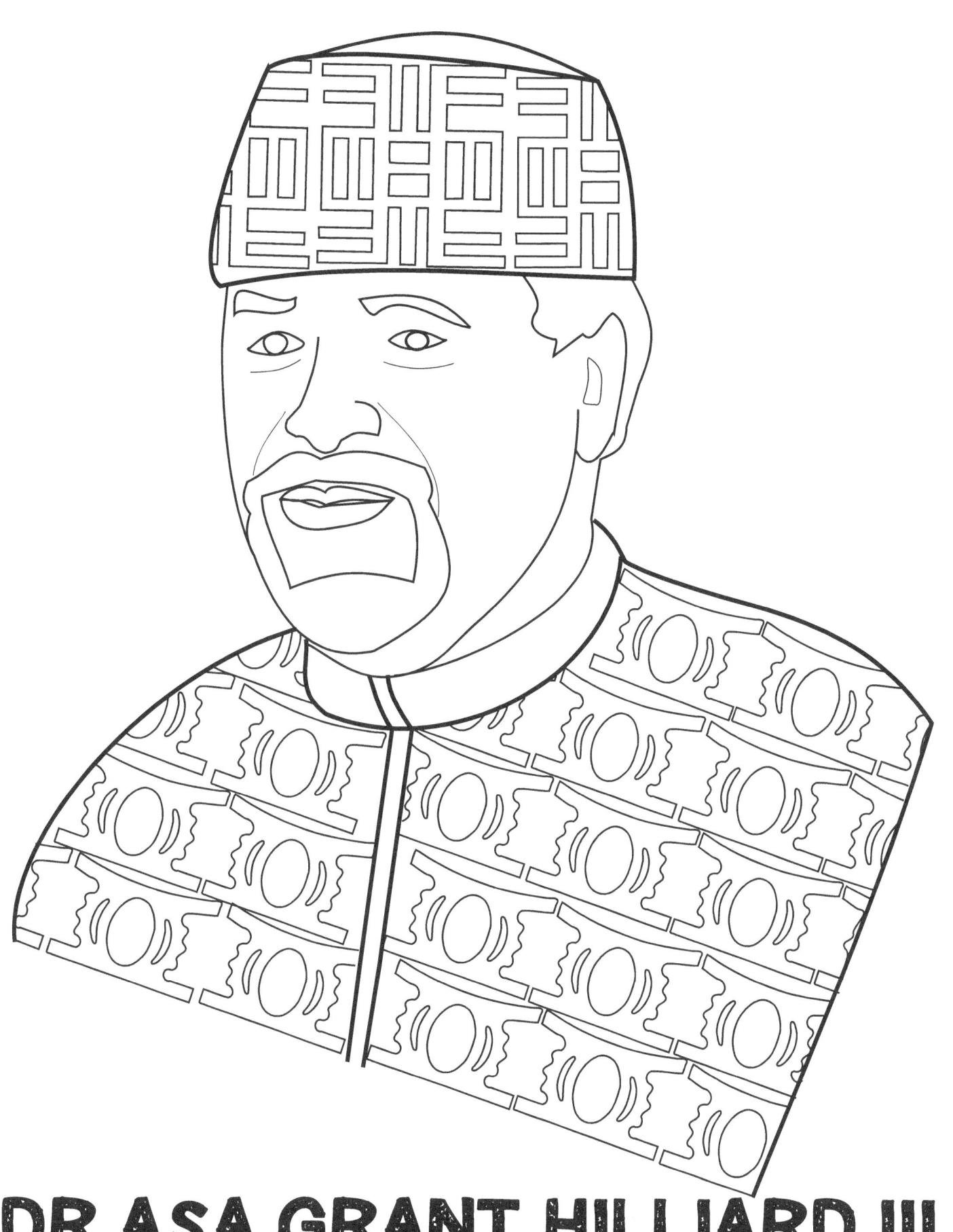

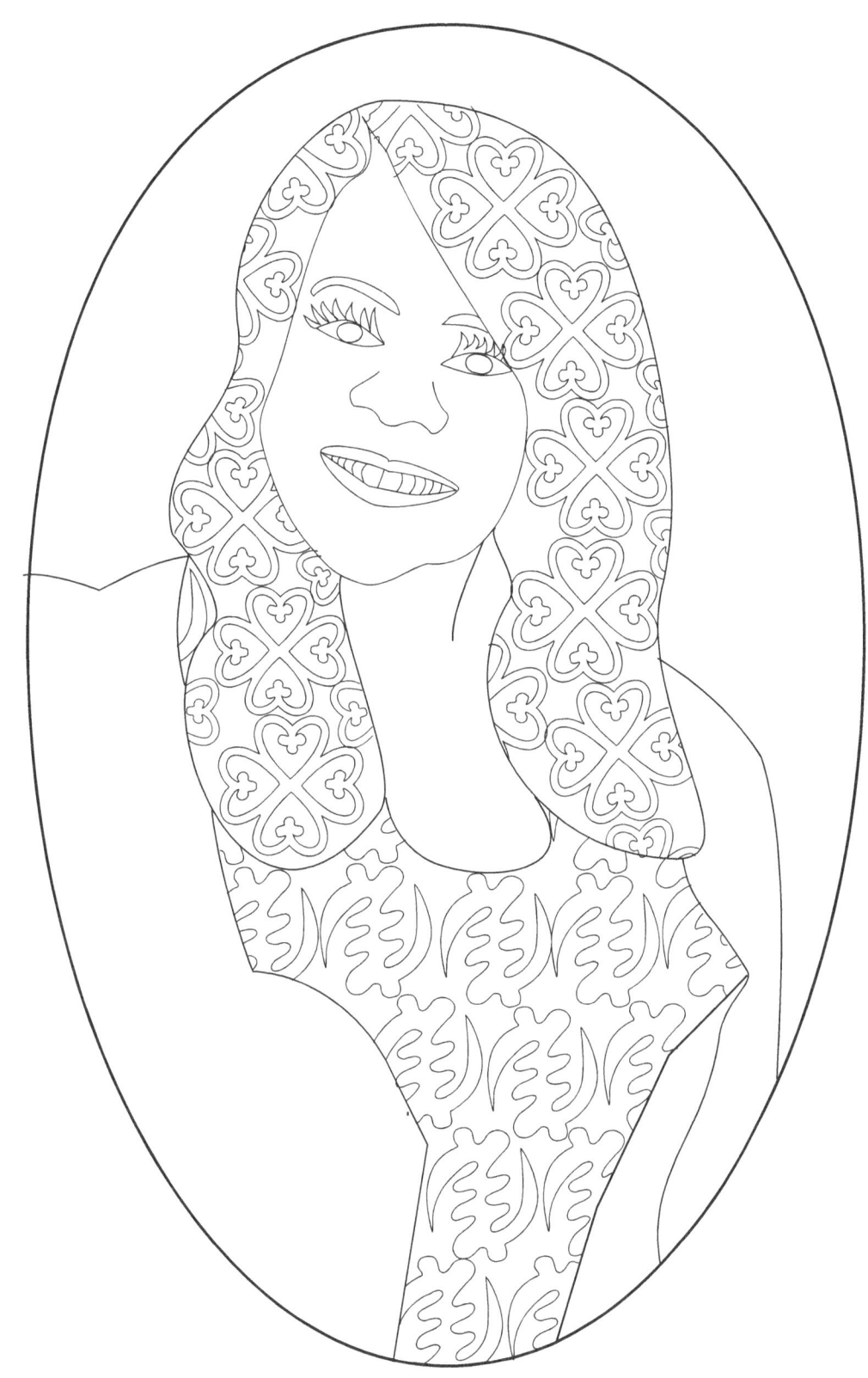

APOSTLE CHERYL M PEEPLES

21ST CENTURY QUEEN AND UNSUNG HEROINE

ADINKRA GLOSSARY

The illustrations in this book are adorned with West African Adinkra symbols. This glossary highlights the symbols used in this book and their meaning.

	WAWA ABA "seed of the wawa tree" hardiness, toughness, perseverance		NYAME BIRIBI WO SORO "God is in the heavens" hope
	KODEE MMOWERE "talons of the eagle" bravery		DWENNIMMEN "ram's horns" strength
	ASASE YE DURU "the Earth has weight" providence and the divinity of Mother Earth		NYAME YE OHENE "God is King" the majesty and supremacy of God
	BOA ME NA ME MMOA WO "help me and let me help you" cooperation and interdependence		DONO NTOASO "double drum" unity and agreement
	HWEMUDUA "measuring stick" examination and quality control		BESE SAKA "sack of cola nuts" affluence, power, abundance, plenty, togetherness and unity

ADINKRA GLOSSARY

The illustrations in this book are adorned with West African Adinkra symbols. This glossary highlights the symbols used in this book and their meaning.

	NYAME DUA "God's Altar" God's protection		**NEA ONNIM NO SUA A OHU** "he who does not know can know from learning" knowledge, life-long education, and continued quest for knowledge
	PEMPAMSIE "sew in readiness" readiness, steadfastness, hardiness		**AYA** "fern" defiance
	ANANSE NTONTAN "spider's web" wisdom, creativity and the complexities of life		**EPA** "handcuffs" law and justice, slavery and captivity
	GYAWU ATIKO valor and bravery		**DAME-DAME** intelligence and ingenuity
	FUNTUMFUNAFU DENKYEM FUNAFU "Siamese twin crocodiles joined at the stomach" democracy and oneness irrespective of cultural differences		**AKOFENA.** "sword of war" courage, valor, and heroism

ADINKRA GLOSSARY

The illustrations in this book are adorned with West African Adinkra symbols. This glossary highlights the symbols used in this book and their meaning.

	SANKOFA "return and get it" positive reversion		**GYE NYAME** "except for God" the supremacy of God
	OHENE TUO "the King's gun" greatness		**NYANSAPO** "wisdom knot" wisdom, ingenuity, intelligence and patience
	ODO NNYEW FIE KWAN "Love never loses its way home" the power of love		**EBAN** "fence" security and protection
	FAWOHODIE "independence" independence, freedom, emancipation		**OSIDAN** "the Builder" creativity
	MATE MASIE "what I hear, I keep" wisdom		**OHEN ADWAE** "The King's Stool" the state and chieftaincy

Dr. LaShawnda Lindsay-Dennis, The Crafty Ph.D.

A native of Jacksonville, Florida, LaShawnda is a formally trained African-centered educational psychologist, mental health counselor, and social scientist. In 2013, LaShawnda discovered her natural talent for "making" and merged it with her knowledge of and love for West African art and culture to launch Ananse Design Essentials. She is a self-taught craftswoman who creates each item from start to finish. Ever since then, she has constantly evolved as a maker, artist, entrepreneur, scholar, craftswoman, and activist.

LaShawnda served as a college professor for over seven years and is currently a research scientist at the Wellesley Centers for Women. In 2015, she was recognized by The Augusta Metro Chamber of Commerce, in partnership with Augusta Magazine, as one of Augusta's ten most outstanding young professionals. She is also the founder of Black Girls Matter, a social media campaign to bring awareness to issues that Black girls face in global society.

With deep devotion, LaShawnda has vigorously accepted the call to enhance the well-being and lives of Black girls globally. Her wide array of research over the past decade has created a platform that sheds light on the social determinants, racial injustices, and cultural biases that burden the progression and viability of Black women. This devotion emerges in her scholarly work as well as her craftswomanship.

LaShawnda is also the author of two other coloring books for grown ups — *Ebony Essence* and *Ebony Essence Families*.

To learn more about LaShawnda and her work, visit AnanseDesignEssentials.com

www.ingramcontent.com/pod-product-compliance
Lightning Source LLC
Chambersburg PA
CBHW081618220526
45468CB00010B/2931